ALINE COQUELLE

THE *Cartier* POLO GAMES

ASSOULINE

Cartier
International Polo

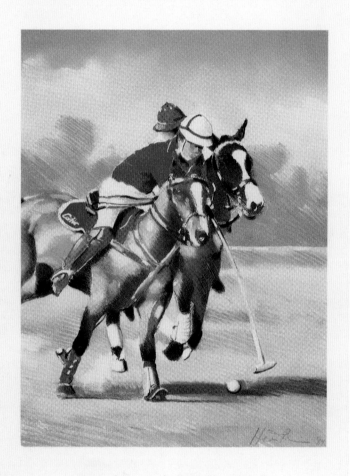

Sunday, July 28th 1985
at The Guards Polo Club
Windsor Great Park

England v Mexico
and
England II v Brazil

P olo has its legend. It is a legend of uncertain origin, coming out of the steppes of Central Asia, between Mongolia and China, Persia and Arabia, and perhaps even Tibet. It was more than twenty-five hundred years ago: the most valiant warriors were the elite players. Fearless, unified, and brave beyond measure, these knights were also masters of strategy. For, from its beginnings, polo has had a mission to shape itself after the art of war and retain its essential sense of being a team game. In the time of Alexander, Darius,

OPPOSITE: Invitation cardboard (Windsor, 1985).
FOLLOWING PAGES: Cartier Polo World Cup on Snow, St. Moritz, 1985.

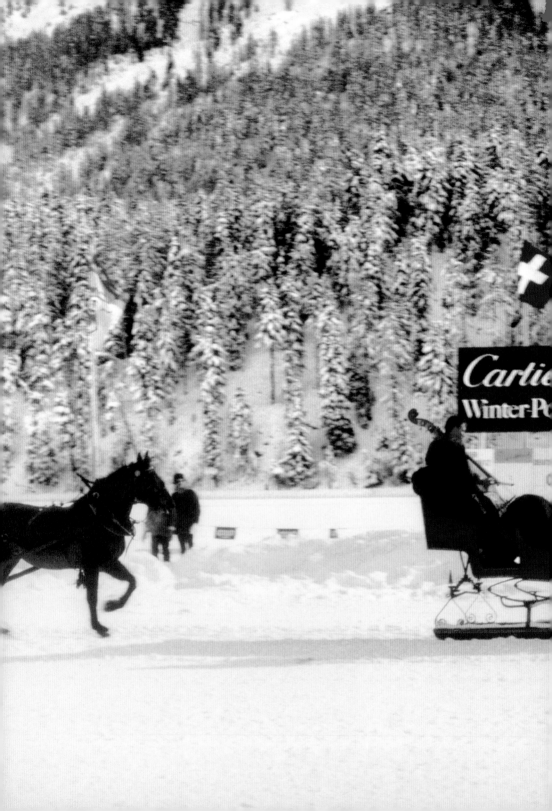

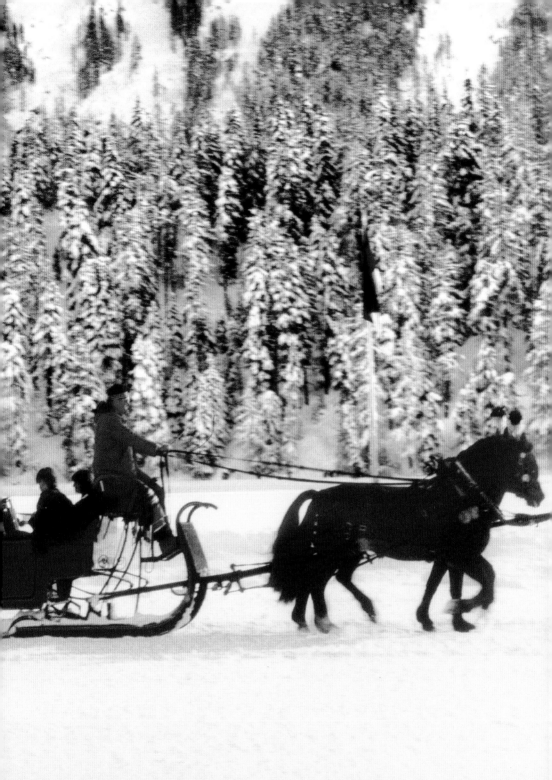

and Genghis Khan, polo was considered to be a fundamental training exercise for cavalry troops. It was meant to develop self-mastery and courage, and to sharpen a sense of team spirit, competition, conquest, and decision-making. It was an important art. In 1859, British major Sherer, a lieutenant with the Bengalese army at the time, became captivated by the sport and immediately wanted to become familiar with its rules. The first historic team was formed in Calcutta in 1863. From this time forward, polo seduced Westerners. In 1869, the first match was played in England, in Hounslow Heath in Middlesex, and in 1874, the legendary first Western team, named Hurlingham, was created in London. In Paris, the first games were played in 1891, two small gallop steps away from the first historic French Bagatelle Polo Club, founded in 1893.

Loyal to its tradition of conquest, polo then began to spread across the globe. The English would take this new passion right to the vast plains of the Argentinean pampa, to the isolated *estancias*, or ranches, where wild horses roamed across thousands of acres of land. The first official match took place in 1875 and immediately bloomed into a genuine lifestyle. The Argentineans considered it a national sport. *Criollos*, small feisty horses with great stamina, were the ideal mount. They were gradually crossbred with purebloods to increase speed and sharpen a sense of competition. Today these horses have set an international standard, as have contemporary Argentinean players, like the champion Adolfo Cambiaso and top-flight teams such as Pieres, Heguy, Novillos-Astrada, and Merlos. Polo was introduced in the United States in 1876 by James Gordon Bennett, the owner of the *International Herald Tribune* and quickly took root in Texas, the Hamptons, California, North Carolina, and Florida. It is in Palm Beach that the second tournament on the most important international circuit is played in Palm Beach. It is

the U. S. Open (after the legendary Palermo Open in Argentina) where the top champions of the world come face to face.

Today public figures from all domains continue to keenly appreciate and practice this "sport of kings and king of sports," as does a handsome community of cosmopolitan aficionados and enthusiasts. From Sotogrande to Dubai, not to mention Chantilly, Ladakh, Marrakesh, Windsor, St. Moritz, Mexico, Buenos Aires, and other hot spots, the magic of polo continues to illuminate timeless moments in life with elegance and conviviality.

throughout the world, polo is an exclusive escape that offers a spirit of confidentiality combined with fraternity. Strong bonds of respect and complicity unite men, horses, and their environment. Networks of friendships are formed with each tournament. A nomadic, sophisticated but casual lifestyle is perpetuated, which is refined and glamorous, traditional and modern. Discovering this world of polo means learning a real lesson in style, one that is inspiring and seductive. this nomadic life is filled with adrenaline, punctuated with gallops, swings and whips, scoring, interlocked mallets, and seven-minute chukkers, laughs, cries, and stares. Life's tempo is sped up, intensified, and boosted with energy and beauty. After the game, endless nights are celebrated with parties and banquets, as the shared lifestyle is enjoyed to its fullest. This is precisely the reason why polo, inextricably linked to an exceptional art of living, met the ideals of Cartier, the French jeweler. Cartier shares the same set of values, based on elegance, passion, tradition, talent, and respect, with the tradition of polo. Also, starting in the mid-1980s, Cartier became a philanthropic body and patron, participating with panache in

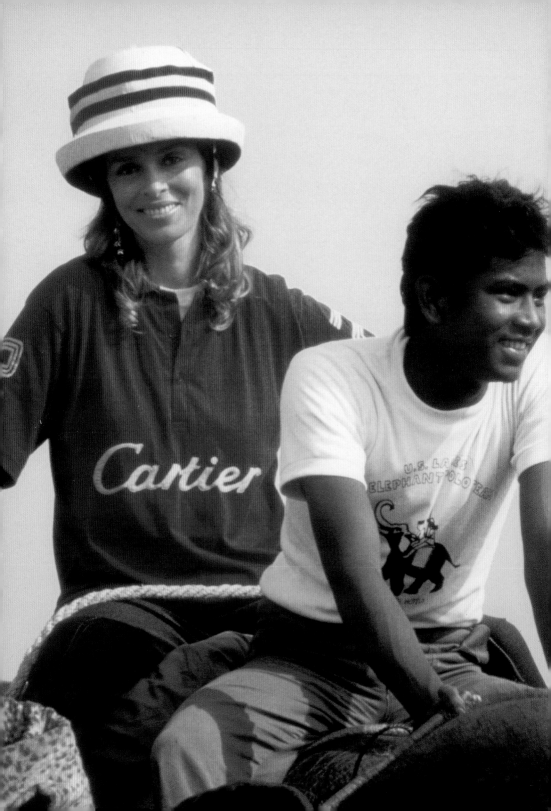

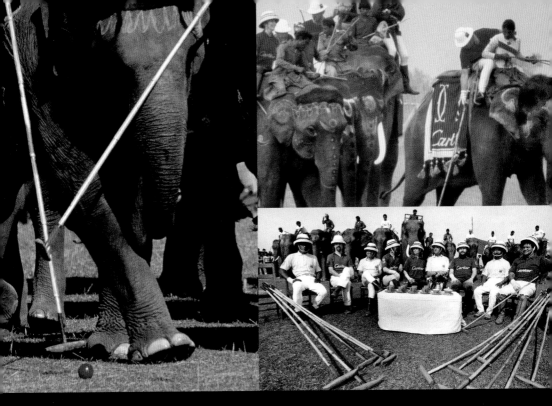

OPPOSITE: Cartier Polo tournament in Nepal, 1985.
ABOVE (from left to right): Cartier Polo tournament in Palm Beach, 1986; Cartier Polo tournament in Nepal, 1985. BELOW: Cartier Polo tournament in Ladakh, 1987.

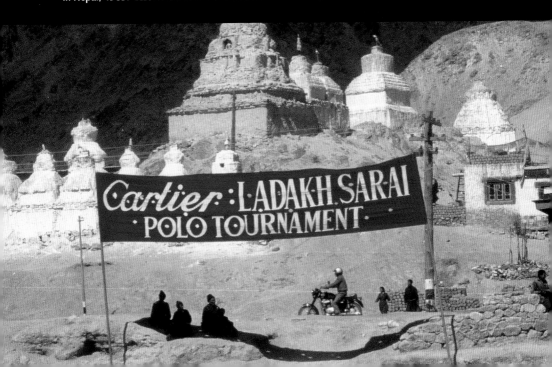

the epic equestrian events in Palm Beach, St. Moritz, Katmandu, Windsor, Dubai, Rajasthan, and everywhere in between.

t he Cartier spirit brings allure and chic to the most unlikely places. For example, in 1986, Cartier took up the crazy challenge of playing on the frozen lake in St. Moritz. And they did it! Top champions have been playing for more than twenty years in the Cartier Polo World Cup on Snow, cheered on by a happy few wrapped in thick furs and taken by the unique Cartier Polo spirit.

In Windsor, at the Guards Polo Club, Cartier has been promoting the Coronation Cup during the Cartier International Polo games since 1985. It's the final and most popular event of the whole season on the British and international circuit. Her Majesty Queen Elizabeth awards the cup to the winners. In the morning, the Golden Jubilee Trophy is often played with His Royal Highnesses Prince Charles and Prince Harry and up to twenty thousand spectators in the stands. As part of this event, the Cartier village hosts a private lunch and tea to match the occasion for British high society. A Cartier must.

In the Middle East, at the oasis created by Ali Albwardy, one of Dubai's most imaginative and polo-passionate tycoons (his luxury complex can survive the arid desert), green acres are offered to the most sportive swings. Her Royal Highness Princess Haya Bint Al Hussein, wife of Dubai's General Sheik Mohammed Bin Rashid Al Maktoum is passionate about horses. She honored the final of the Cartier International Polo Challenge with her presence, launching the event in March 2006 at the Desert Palm Polo Complex. The day-filled event opened new doors, for Cartier's

relationship with polo seems to grow and grow. In Rajasthan, Cartier will sponsor an exceptional polo match to be played on elephant-back as part of a charity event to benefit these pachyderms from the past. Because of its involvement in the world of polo, Cartier tends to transcend the sport's spirit of fantasy, prestige, courage, and passion, identifying instead with the strong, modern, gentlemanly values that evolve with travel and friendship.

A Short Guide to Polo

The Game

The matches are played in four, five, or six periods (known as chukkers), each running seven and a half minutes. A first bell warns umpires after seven minutes of play, and the final bell rings thirty seconds later. The players (four per team) try to drive the ball into the opposing goal, between two posts. There are no height limitations for scoring. After each goal, the teams change sides. There are two mounted umpires, along with a line referee who sits perched above the field along its edge. The umpires are present to separate players in the case of a disagree-ment. They signal fouls with a whistle, which stops the clock. At the end of each period, the players change horses.

The Players

Who are those men in helmets?

Every team has four players:
-number 1 – the attacking offensive player
-number 2 – the mid-field forward player
-number 3 – the pivot man, often the best player
-number 4 – the defensive player
Each player covers his opposing number. So, number 1 covers the other's

12

team's number 4, number 2
covers number 3, etc.

The Ponies

*Players change mounts after
each period.*

The horses, traditionally
called ponies, are perfectly
trained, tame, and brave.
They are able to stop and
turn quickly. Over short dis-
tances, they are faster than
purebreds. The horses are
the most important elements
of a team and are cared for
by grooms.

Handicaps

*In polo, handicaps are an
integral part of the game.*

The players are assigned a
handicap between -2 to
+10 (10 being the best
handicap). A team's handi-
cap is the combined handi-
caps of the players. In an
open match, no advantages
are given to the weakest
team. In a handicap match,
points are granted to the
weakest team.

Penalties

Foul! What foul?!

Penalties are called by the
umpires at different points
on the field and depend on
the direction of the game,
the seriousness of the foul,
and the area in which it was
made. In extreme cases, a
goal is automatically granted
to the team that was fouled.
On the field, lines indicate
from where penalty shots
may be taken: from the mid-
field, 30, 40, 60 yards from
the goal. If the ball rolls
over the back line as a
result of being touched by a
defending player, the offen-
sive team is awarded a
safety penalty shot from 60
yards toward where the ball
left the field.

Fouls:
A brief explanation

*An imaginary line-of-ball
establishes a player's right-
of-way.*

For beginners and profes-
sionals alike, it is very diffi-
cult to see fouls. You need
only to listen to players
when the umpire whistles!
Any dangerous action is
considered a foul. When the

ball is struck, it creates an invisible line that the players must follow as if they were on an imaginary road. Since the game was developed by the English, driving is on the left. Every time the ball changes trajectory, the right-of-way changes.

"Sandwich": two players from one team press against the opponent on either side.

"Hooking": a player interferes with the swing of his opponent on the wrong side or at the wrong time.

A technical foul could be called if a player argues the umpire's call.

Customs:
Divot Stomping

Dogs, shoes, techniques, and socializing, or how to take your seat before the announcer yells at you.

For the spectator, this is the most important part of the polo match. It is a specific and unique ritual that is more than a way to get you to work. It is a part of the game, and it has its rules, just like following a musical score. Your job is to replace the mounds of earth torn up by the horse hooves so as to flatten the field. To do so, you need adequate shoes—and you must not stomp on your neighbor's feet. It is recommended that spectators not argue over mounds—this practice is looked down upon. In any case, you will not get all the good ones. Do not let your dog bite the club presidents (or anyone else, for that matter). Do not make fun of anyone else's style. Do not roam about looking for someone with whom to chat; you are there to work. Beware of children with mallets, they will not watch out for you. Be ready to sprint back to your seat at any moment when the bell rings, as the game cannot start up again until everyone has returned to their places. The announcer will not hesitate to yell at you, call out your name if he knows it, and humiliate you publicly.

Collector collection of polo balls signed by the biggest champions (as Bautista Heguy, handicap 10). Originally in wood, polo balls are now plastic.

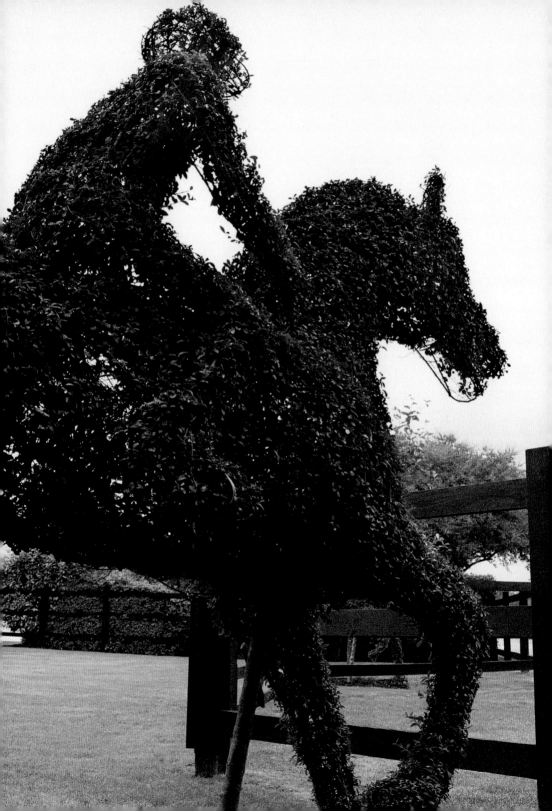

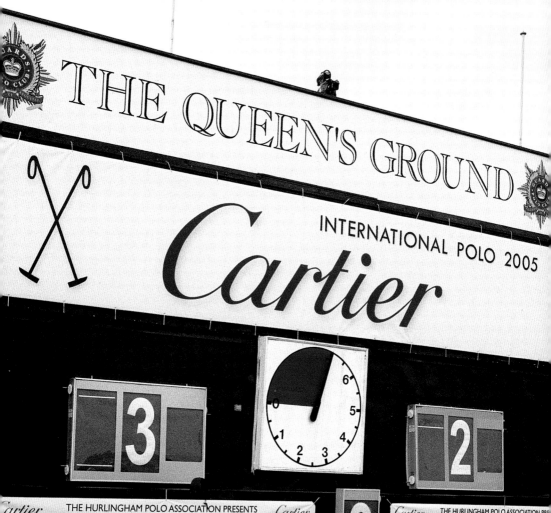

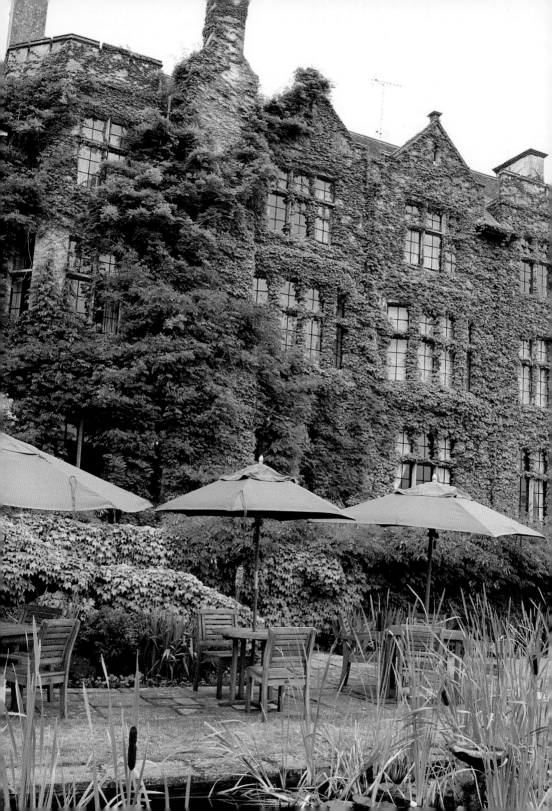

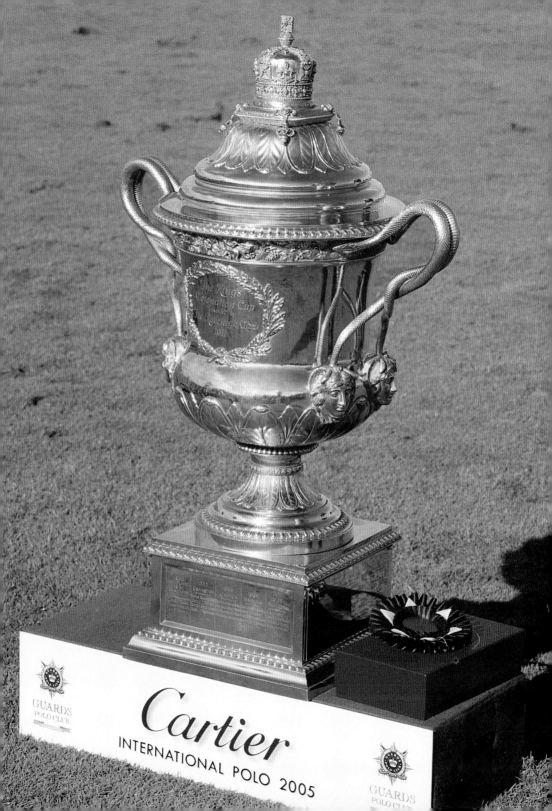

The King's
Coronation Cup
formerly the
Ranelagh Cup
1911

Cartier
INTERNATIONAL POLO 2005

GUARDS
POLO CLUB

GUARDS
POLO CLUB

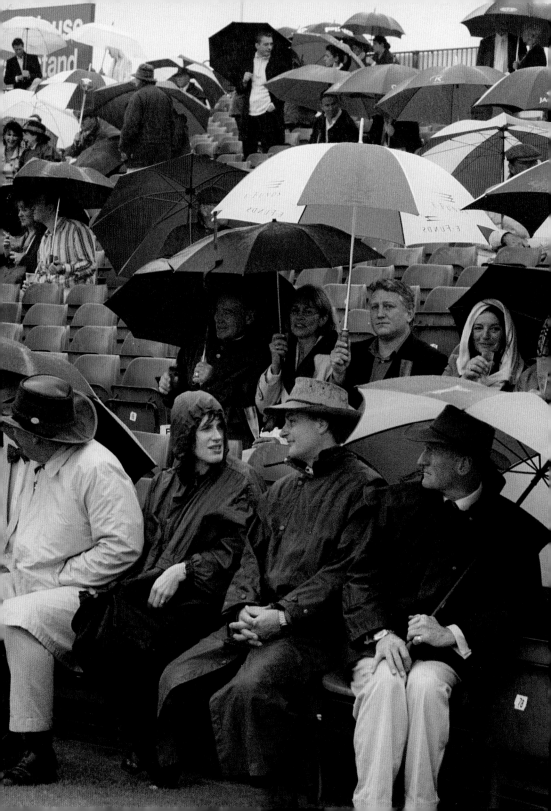

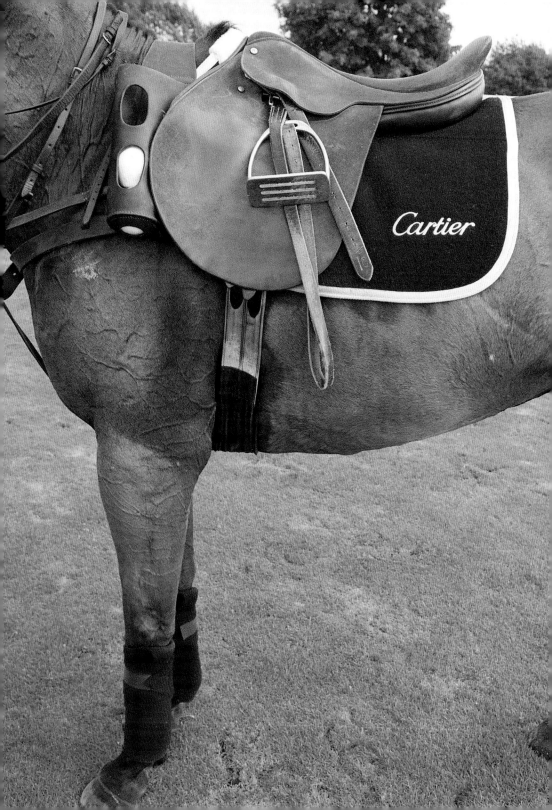

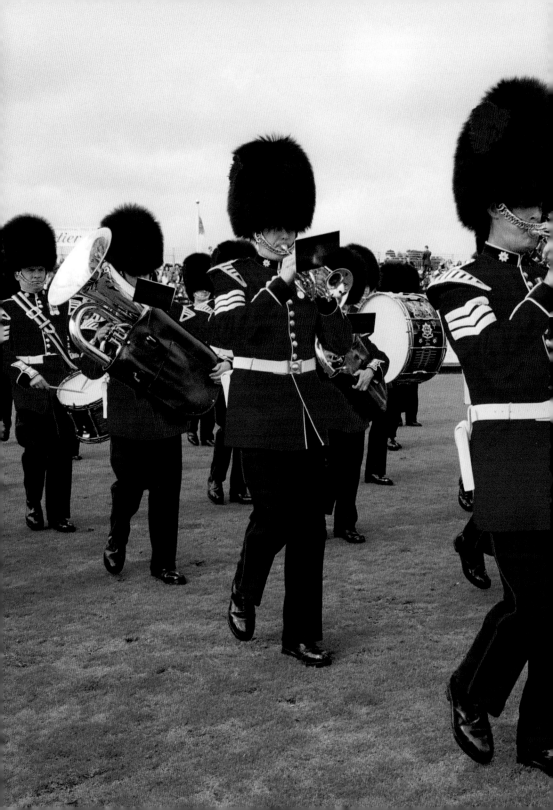

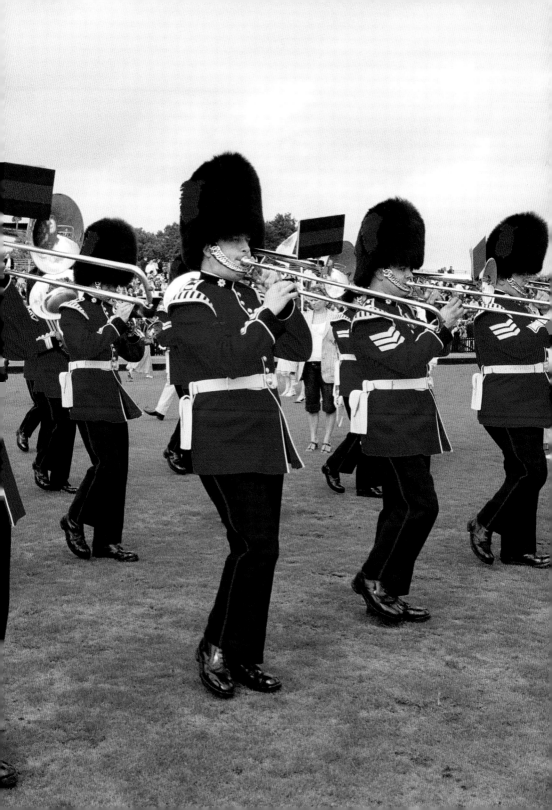

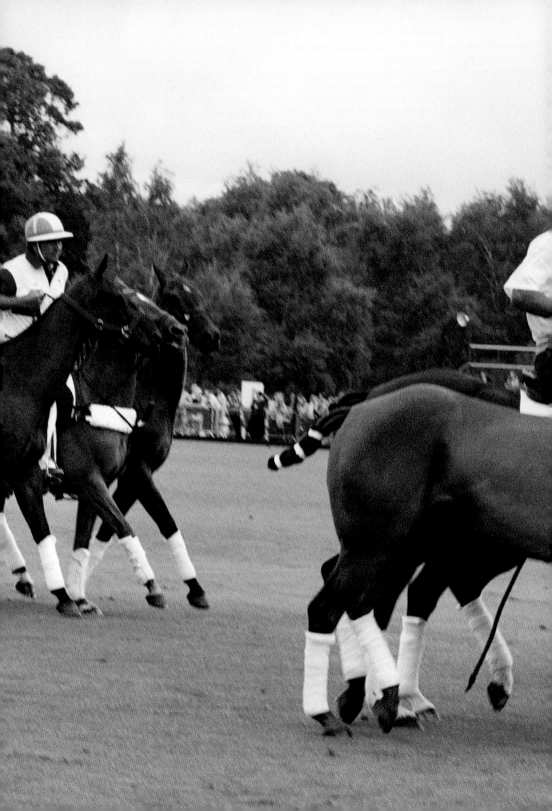

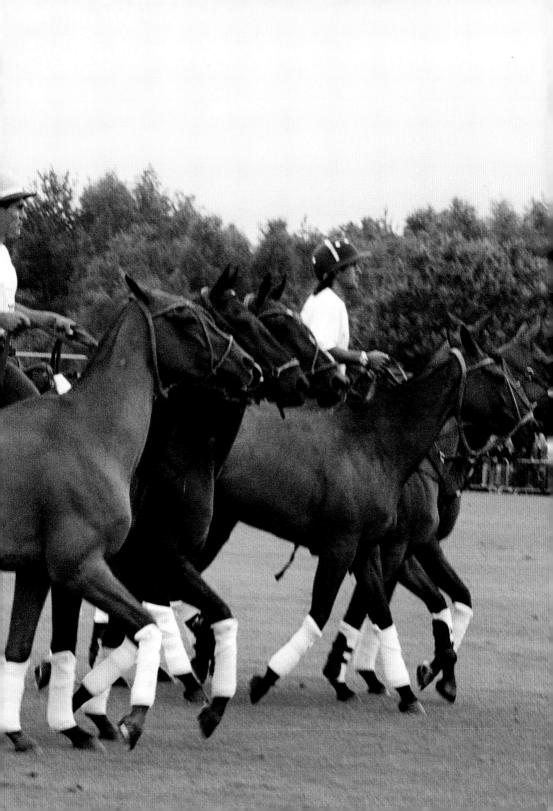

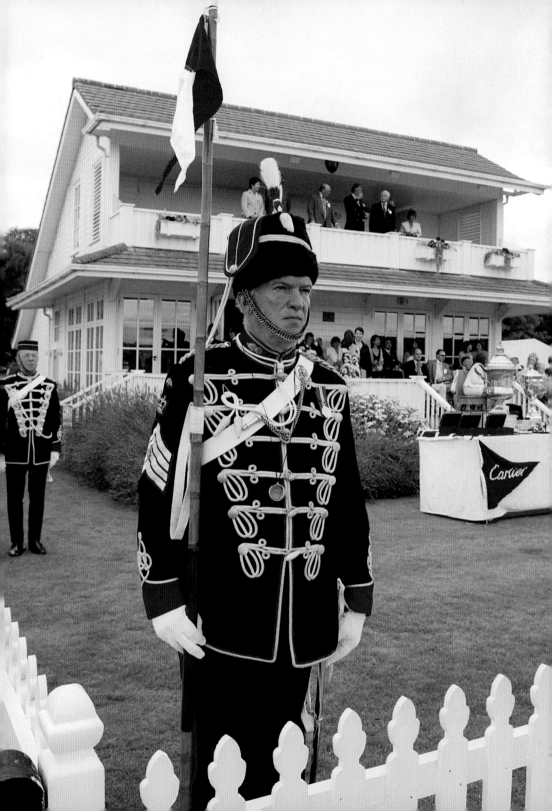

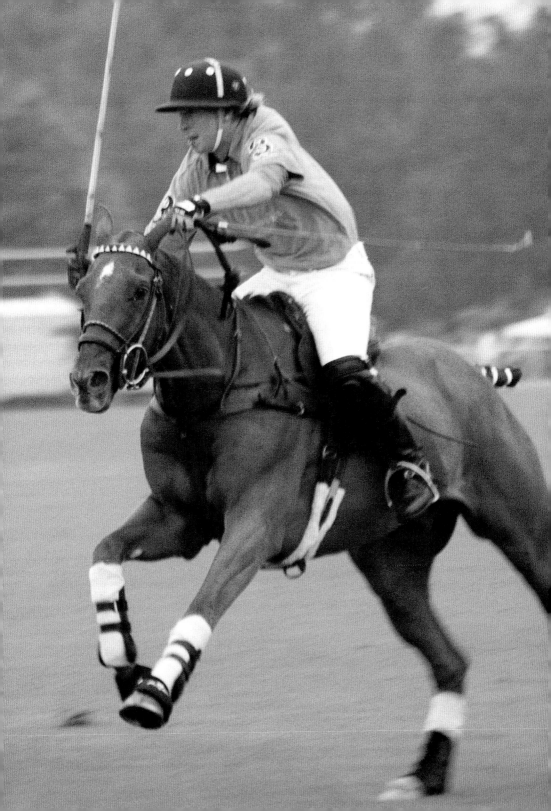

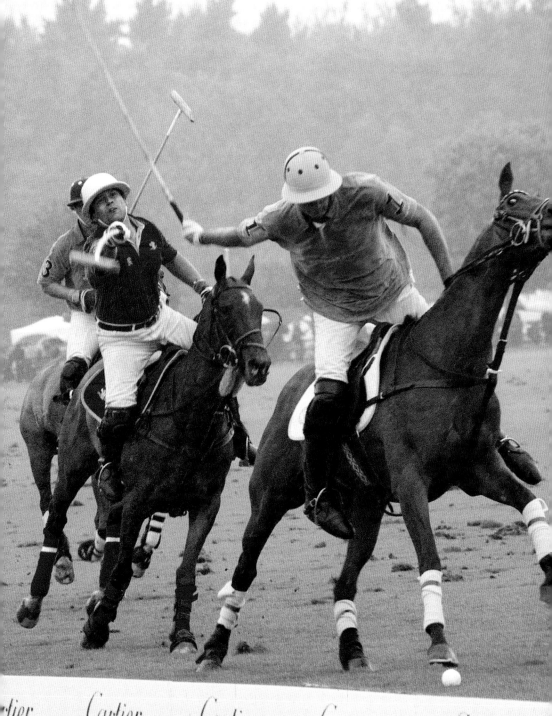

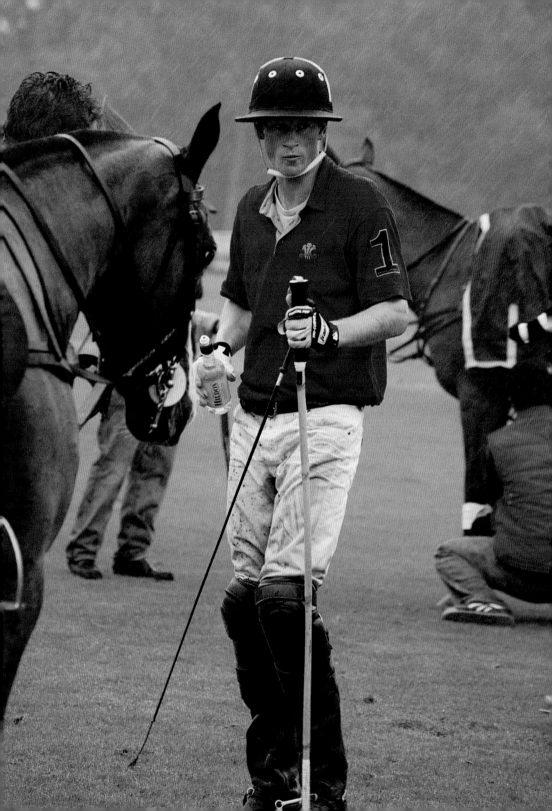

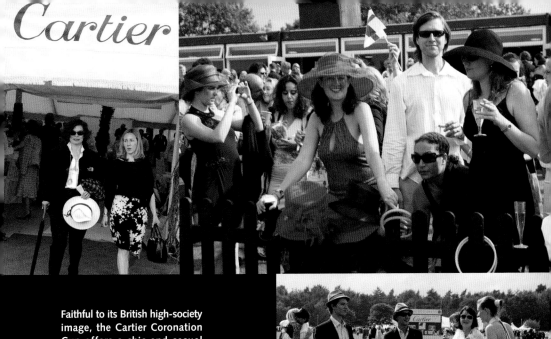

Cartier

Faithful to its British high-society image, the Cartier Coronation Cup offers a chic and casual ambiance that is often graced by the presence of celebrities like Bianca Jagger, Cate Blanchett, and Anjelica Huston.

OPPOSITE: His Royal Highness Prince Harry takes a break before changing ponies for the next period.

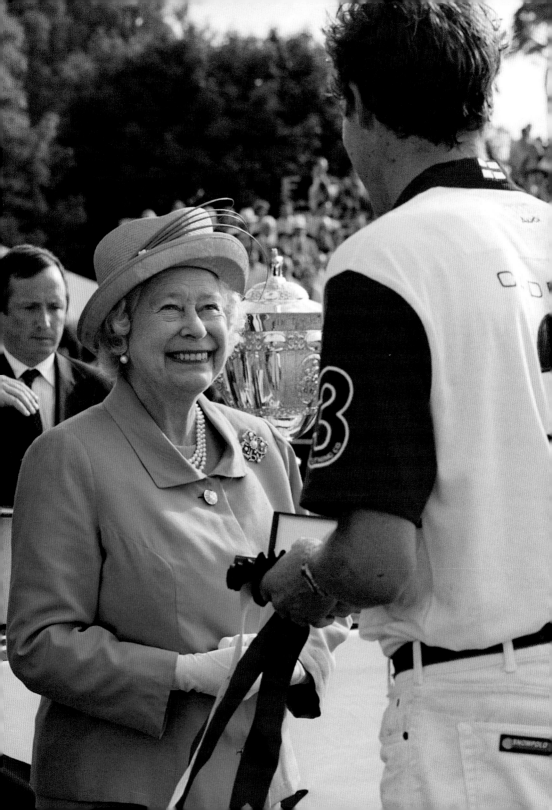

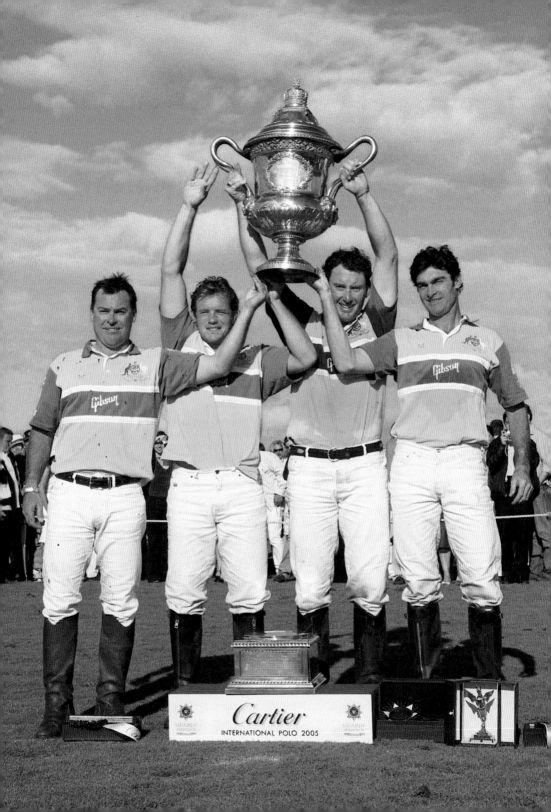

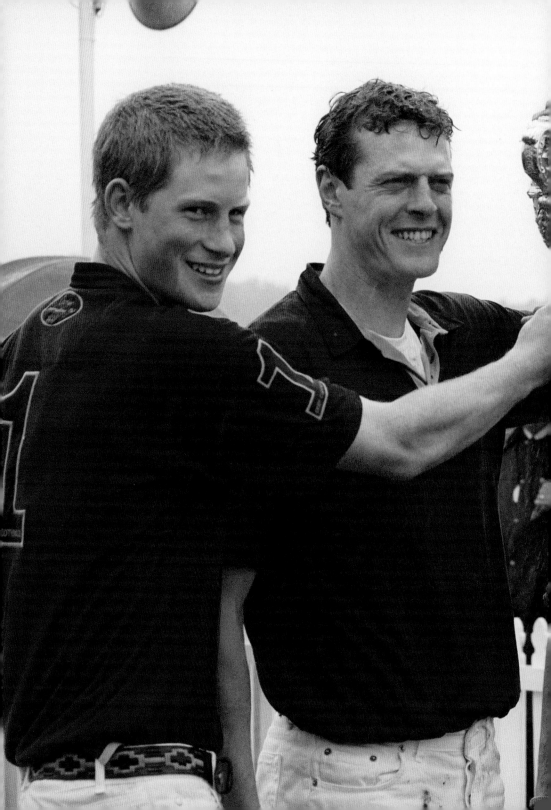

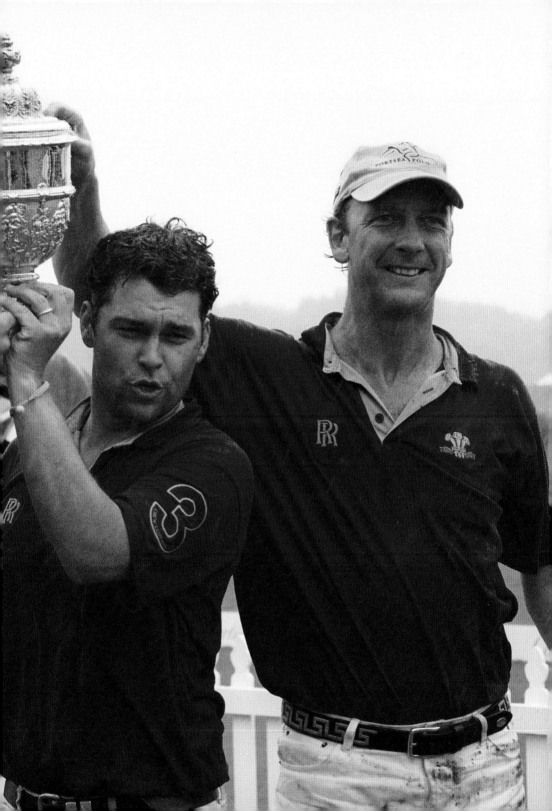

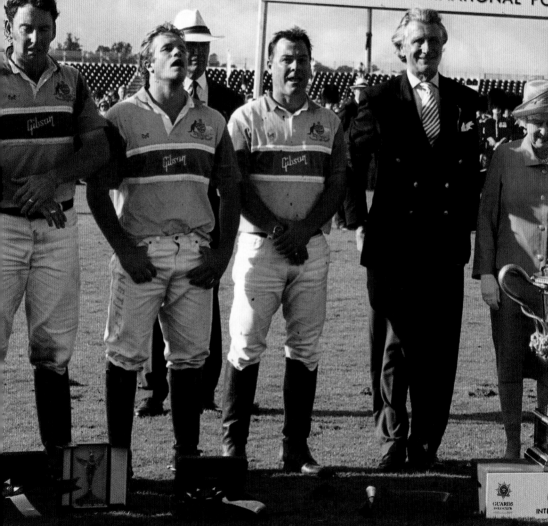

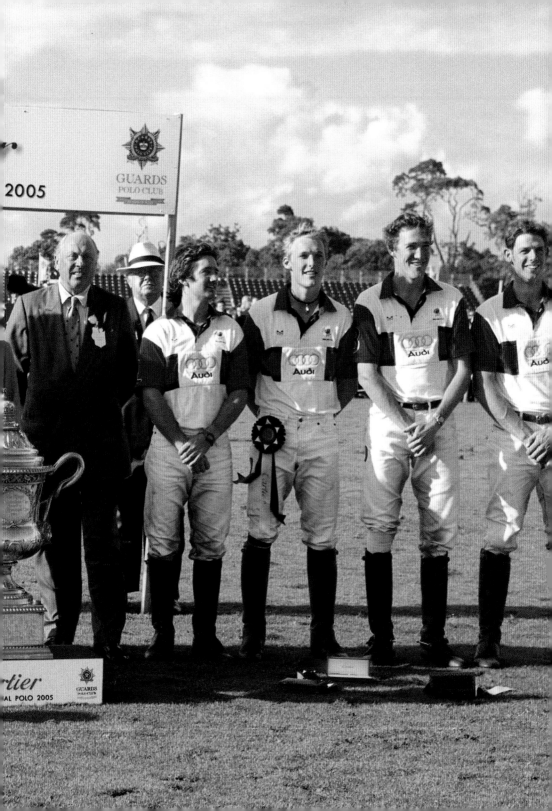

St. Moritz Polo Club

Chukker

Cartier

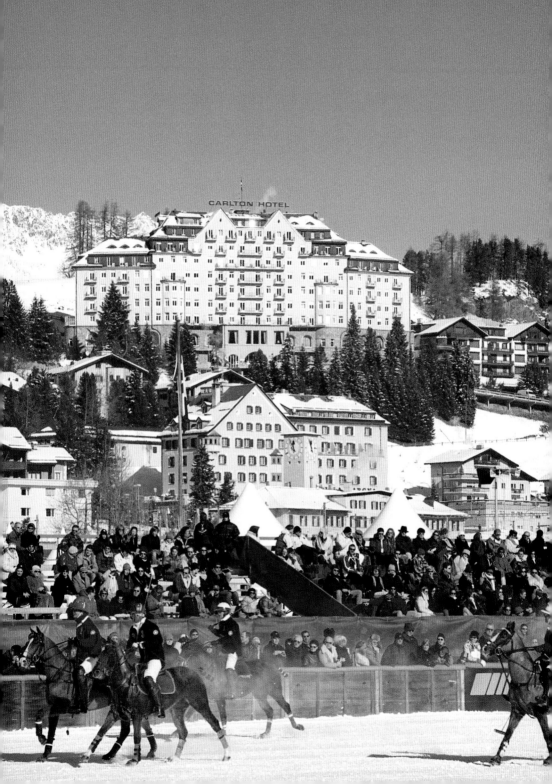

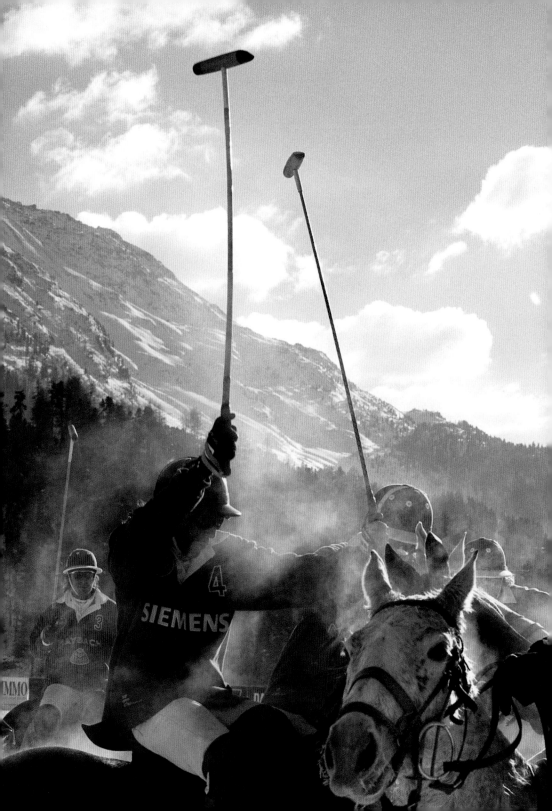

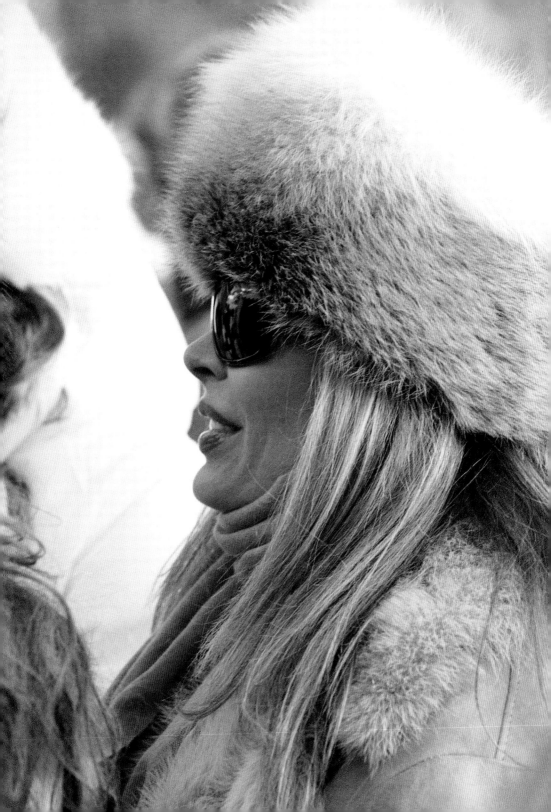

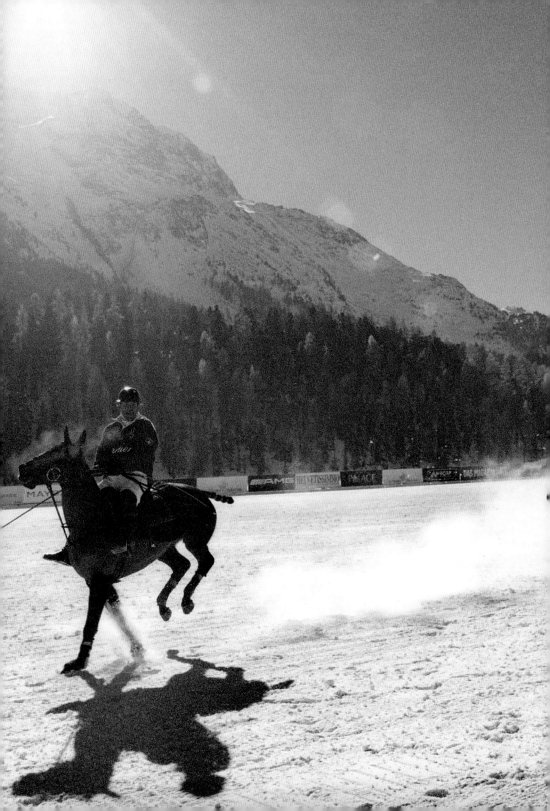

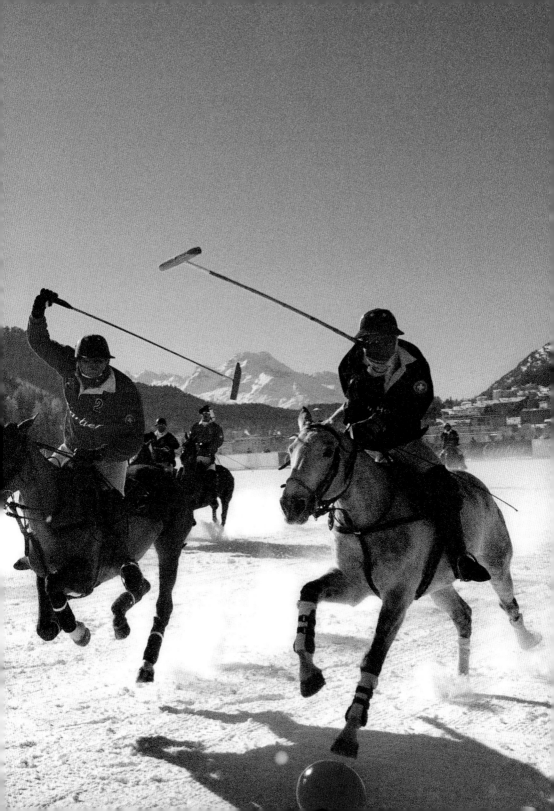

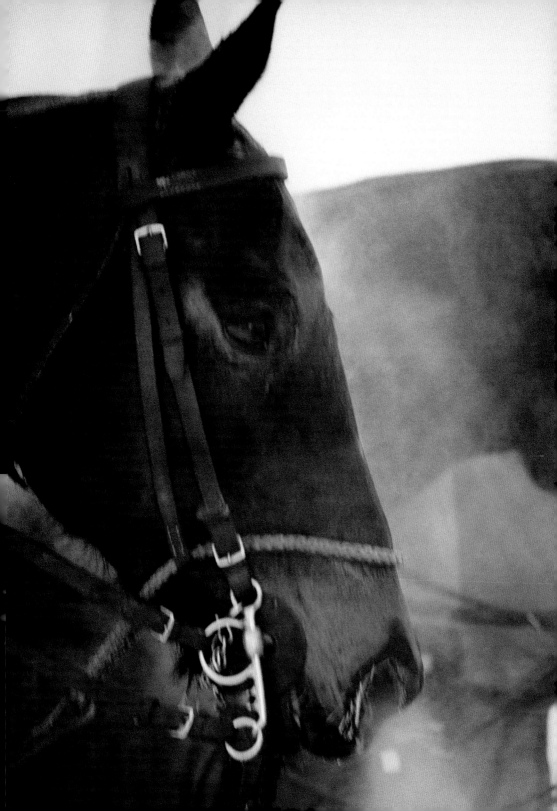

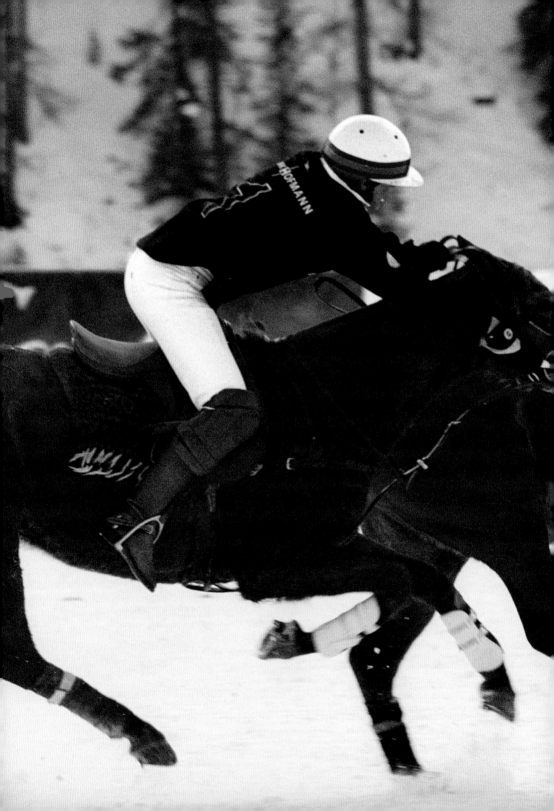

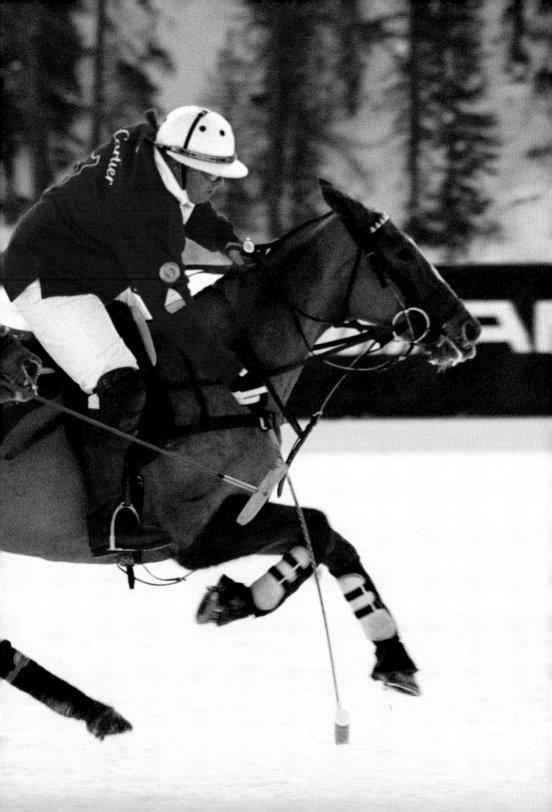

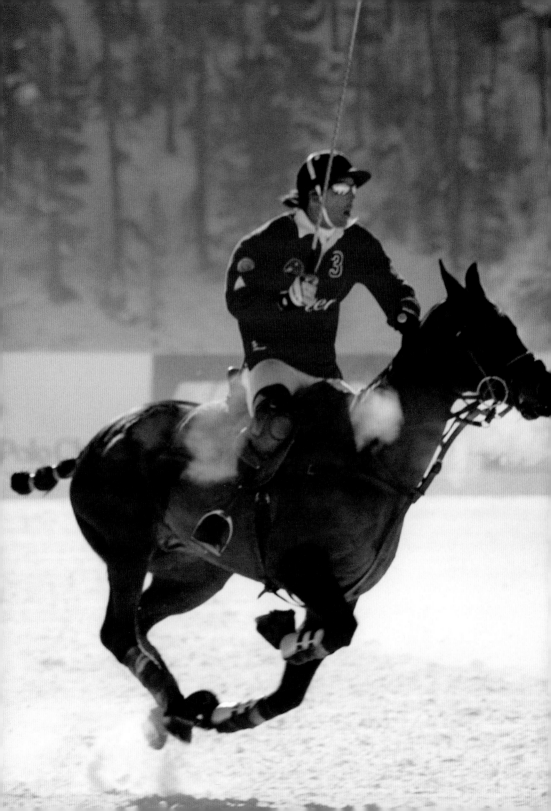

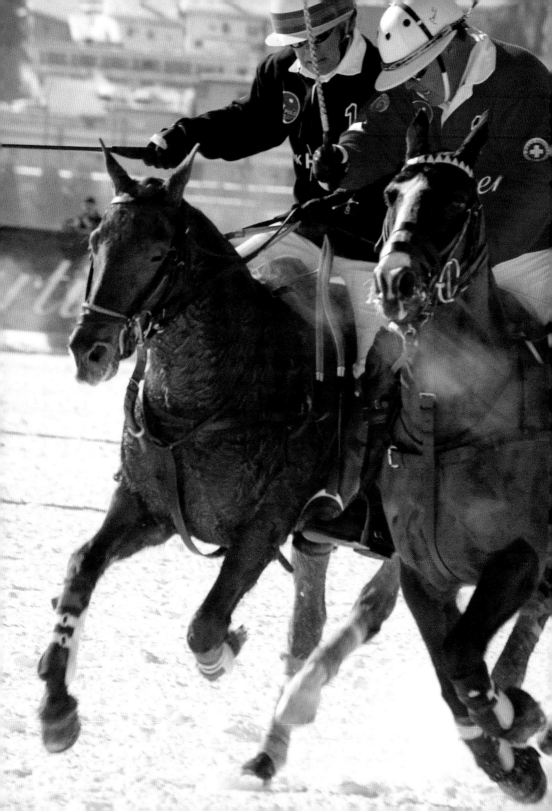

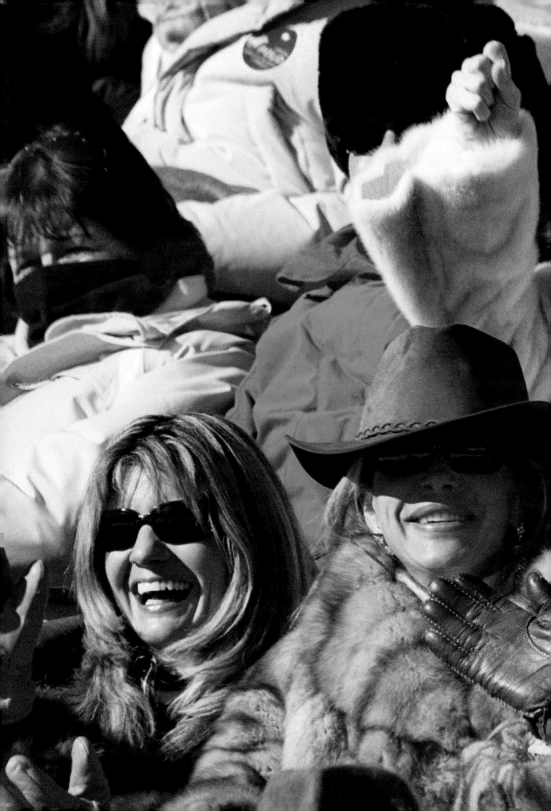

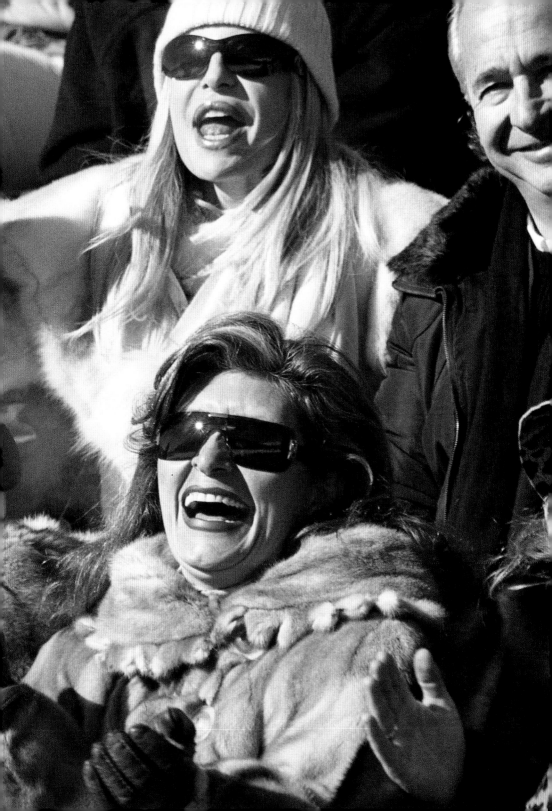

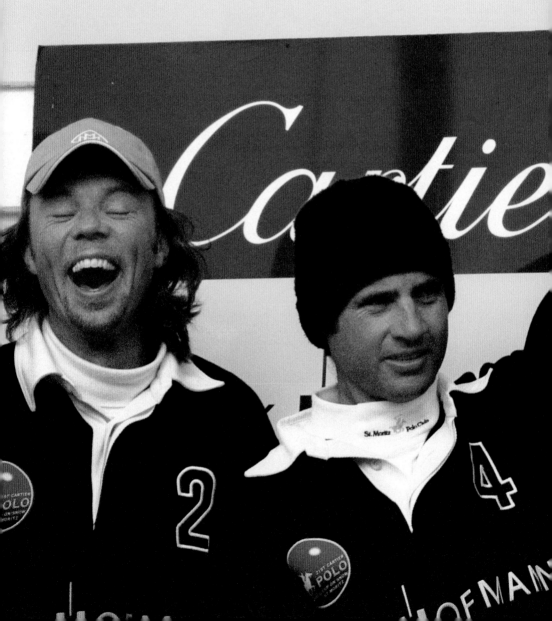

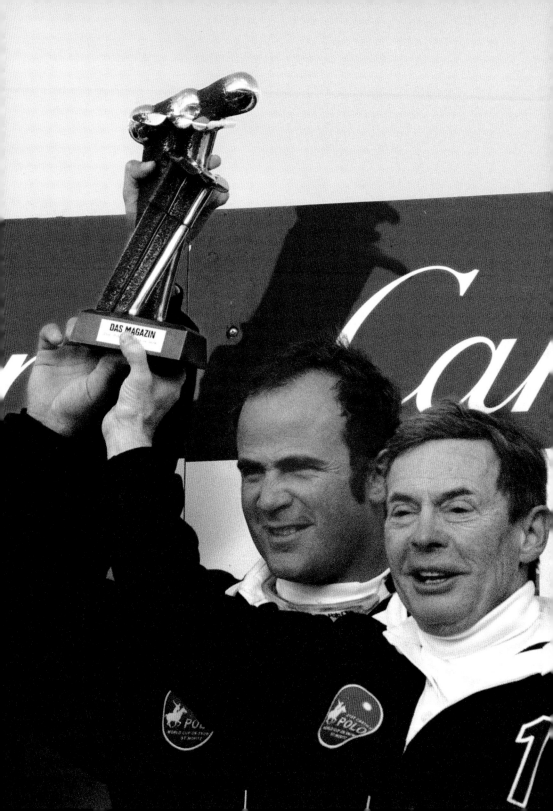

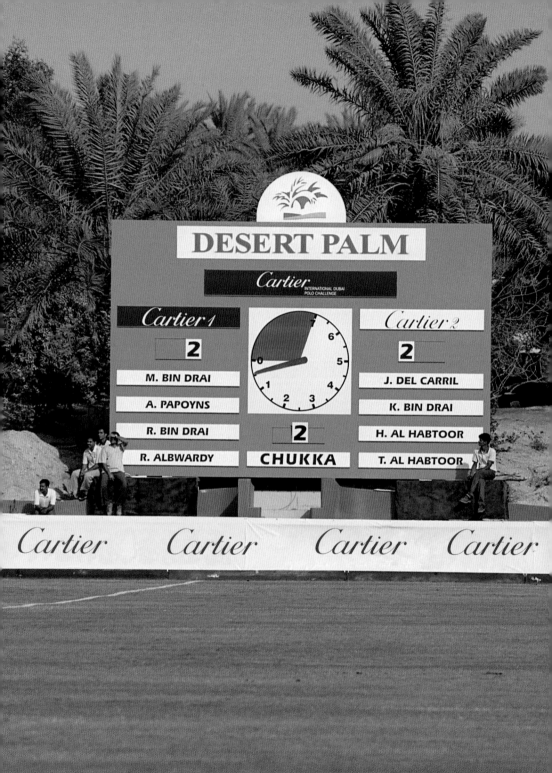

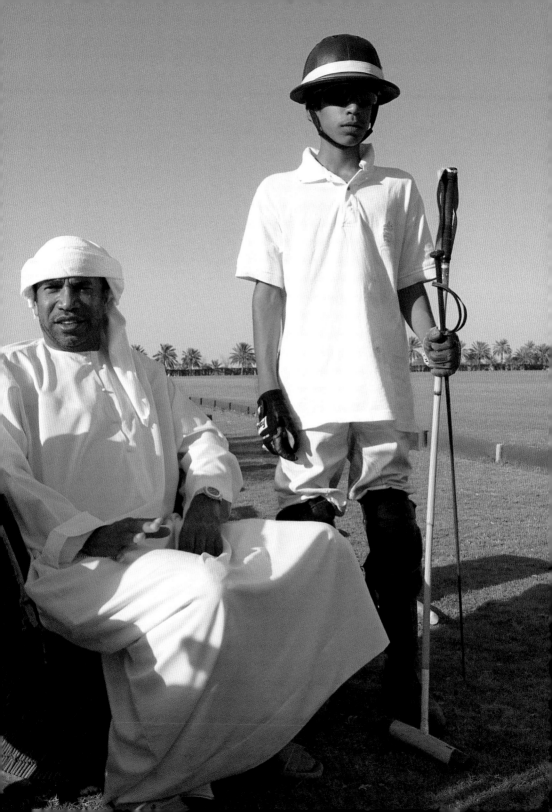

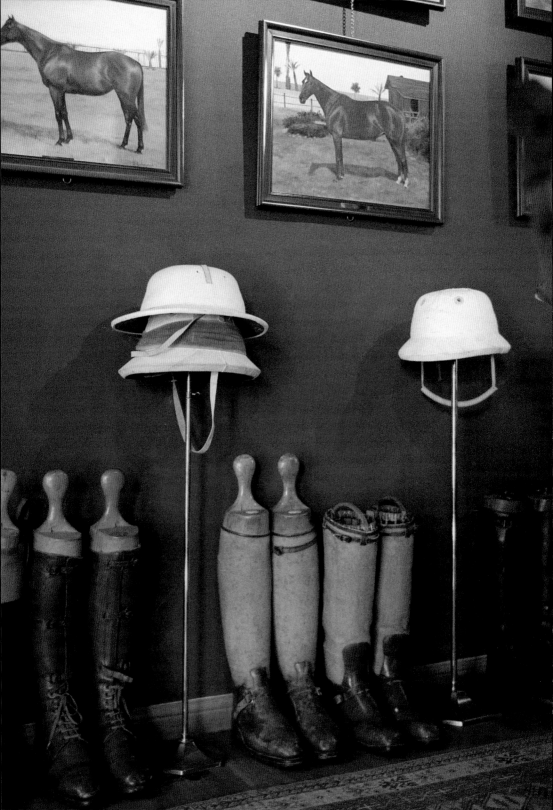

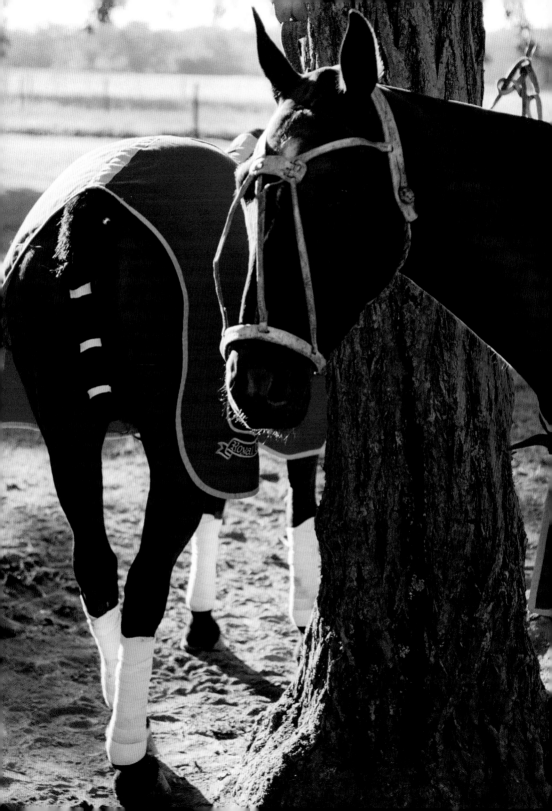

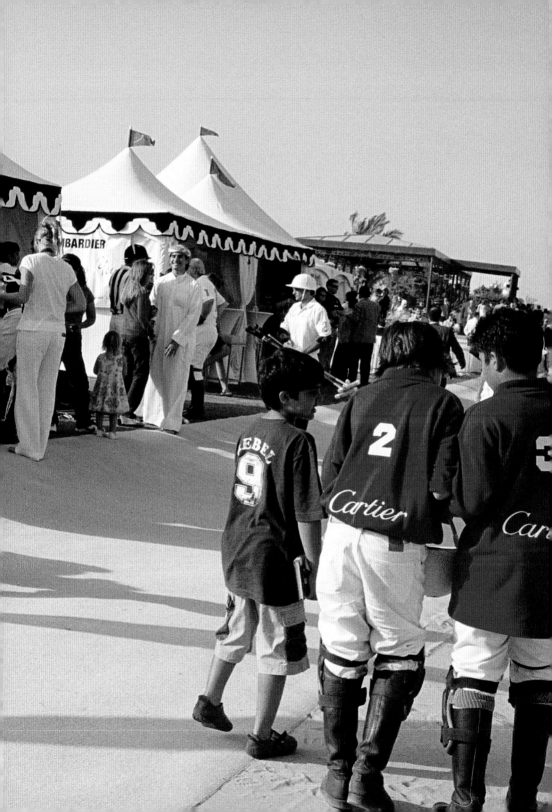

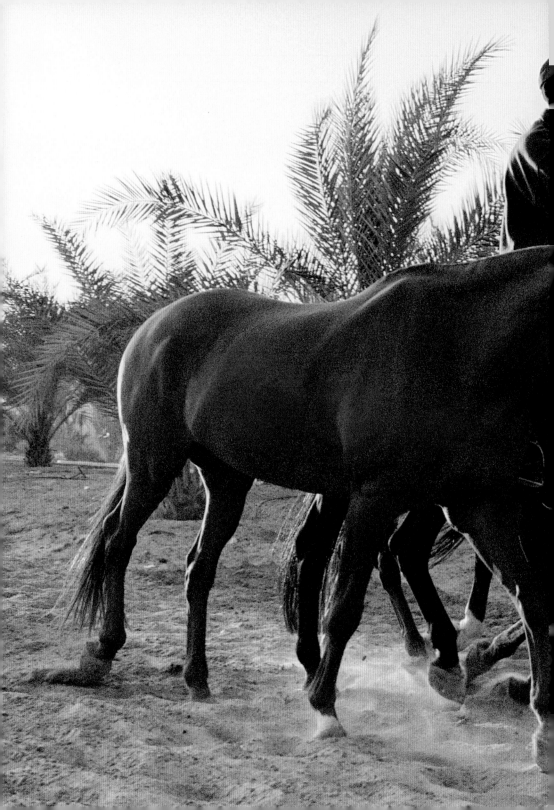

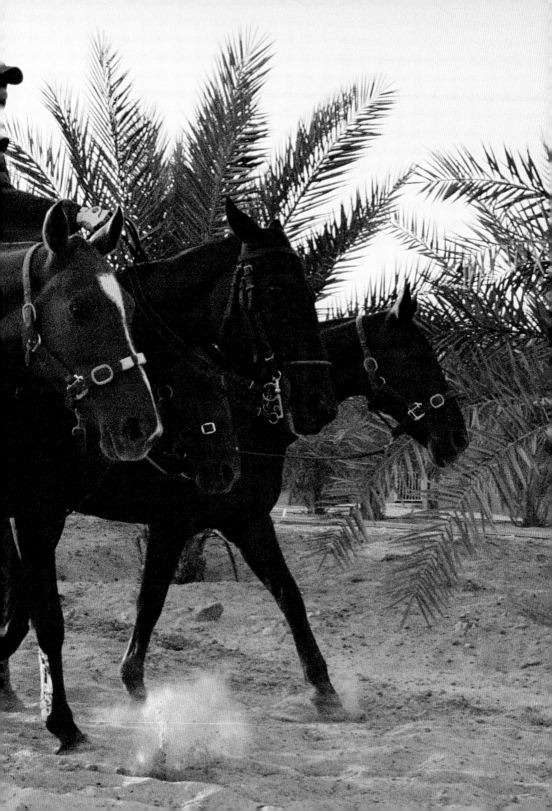

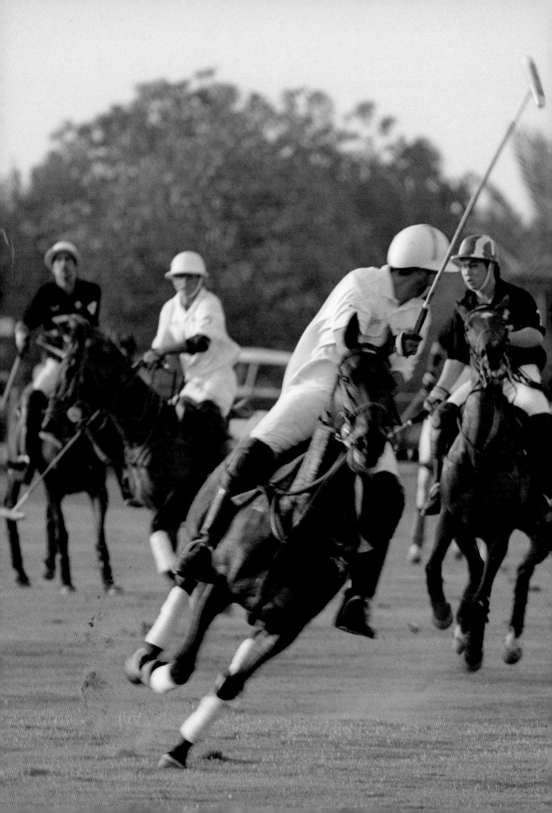

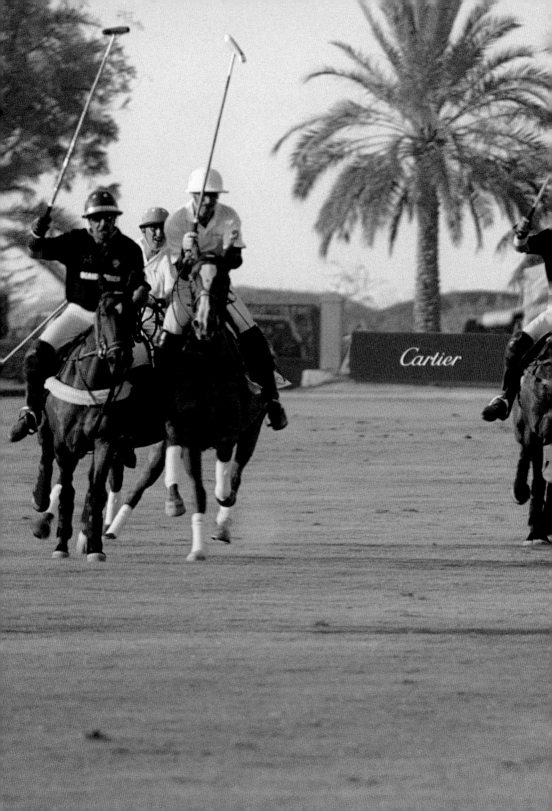

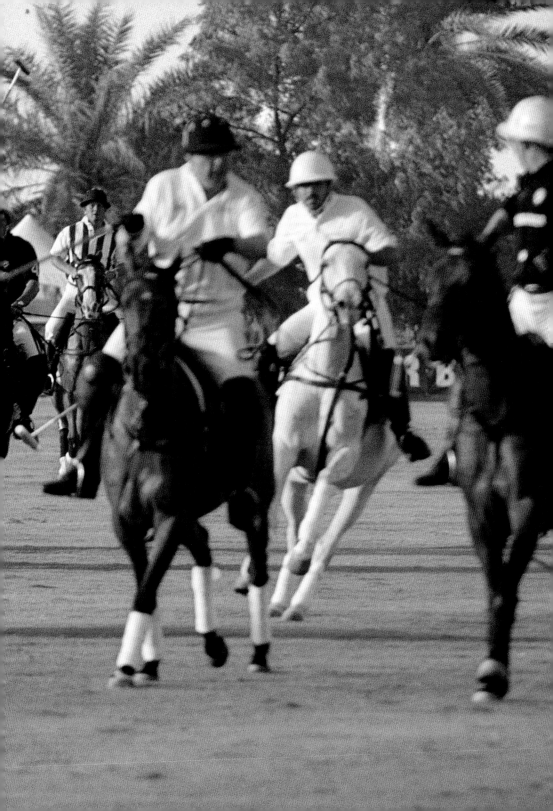

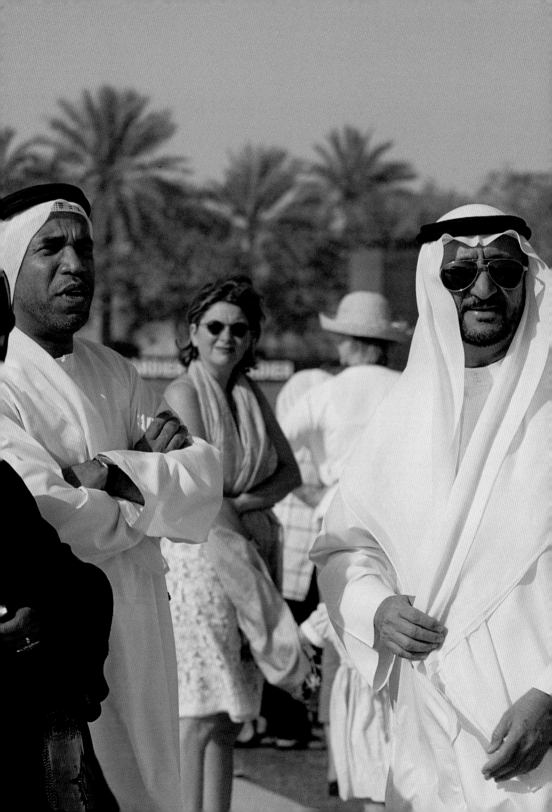

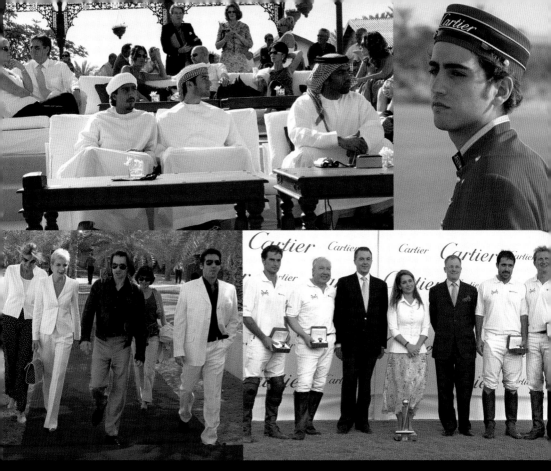

Several moments during the Cartier International Polo Challenge, 2006 in particular (center, right) with Her Royal Highness Princess Haya Bint Al Hussein and the winning team of captain Urs Schwarzenbach, and (center, left) Olivier Martinez surrounded by Christine Borgoltz, Mélita Toscan du Plantier, Pilar Boxford and Jeremy Danster. OPPOSITE: Ali Albwardy (left, with arms crossed) with guests.

THE *Cartier* POLO GAMES

At the Guards Polo Club in Windsor, the hedges look like prestigious adornments, sculpted like works of art. In front, the impressive scoreboard indicates the names of the teams, the score, and the time left in the match, as well as the number of chukkers (game periods lasting seven minutes).

The Penny Hill Park Hotel is a divine and relaxing haven right next to where the matches are played. Set among splendid country vistas, a spa and a top-quality golf course, it attracts a fervent elite that have come to enjoy the Coronation Cup (the Queen's Cup).

Even in the pouring rain, polo lovers watch the **Golden Jubilee Trophy**. Embodying elegance, the mounts are equipped with English saddles and flannel leg wraps that protect them from the balls and mallet swings. Here, an umpire's horse carries a case with extra balls to be used during the game.

As per British protocol, **the Royal Guard inaugurates the start of the Coronation Cup with splendor**, every year facing off the English team with an invited team from abroad. The ritual is part of the prestige of this tournament.

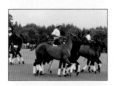

The horses, mounted by polo virtuosos, are paraded in front of spectators **before the match**. Spirited and strong, agile and vigorous, they can accelerate and turn quickly. They are both a major attraction to the games and 70 percent of its talent.

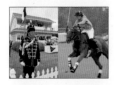

The Royal Guard stands still in front of the official loge, starkly contrasting the wild and intrepid galloping of the game.

Polo lovers carefully follow the evolution of the strategies executed with finesse and strength by the artists playing. The abrupt changes are spectacular, playful, and full of adrenaline and elegance. It's a captivating show, despite the danger of a rain-slicked field, as seen here.

His Royal Highness Prince Harry takes a break before changing ponies for the next period.

Faithful to its British high-society image, the Cartier Coronation Cup offers a chic and casual ambiance that is often graced by the presence of celebrities like Bianca Jagger, Cate Blanchett, and Anjelica Huston.

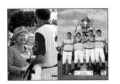

Ravishing, Her Majesty the Queen of England congratulates and awards both the winning and the losing team, as well as the best player and horses! The finest of golden trophies made by Cartier stands beside Arnaud Bamberger, director of Cartier England.

Victorious, the Australian team savors its success: Captain Glen Gilmore (handicap 7); Damien Johnston (6); Ruki Bailieu (8); Mike Todd (6).

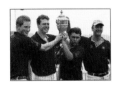

All smiles, the winners of the Golden Jubilee Trophy wave their cup. A victorious Gold Team, consisting of His Majesty Prince Harry (handicap 1), James Harper (6), Nacho Gonzalez (6), and Andrew Hine (captain, 6).

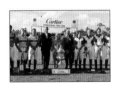

Traditional and predictable photographs around the Coronation Cup, won by Australia after a great match against England by one point in an extra chuckker! A match and performance that held up to its grand promises. England's talented team is led by its incomparable captain Henry Brett (handicap 7), and stars Mark Tomlinson (6), Malcom Borwick (6), and Luke Tomlinson (7).

St. Moritz and its polo grounds at 5,900 feet in altitude. The sublime vista overlooking the Alps and the legendary Badrutt's Palace is the flamboyant home to the Cartier Polo World Cup on Snow. It is a renowned, wondrous world at Christmas time, when horses chase a ball of fire through the snow.

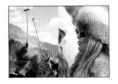

The energy and heat of the game combined with the chilly climate creates a hot-and-cold atmosphere that is both invigorating and artistic. Amazing bouts filled with fresh and boisterous chic captivate every spectator.

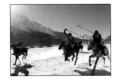

At full speed, horses gallop across a carpet of snow and ice. Crystal dust is raised with every stride, like raw diamonds shining in the eyes of the warrior-players and their speechless spectators.

Inside spotless tents, horses regain their breath after such an improbable game of challenges. A major site-to-see in such a tremendous setting. It is **an exclusive art that is further enriched by Cartier.**

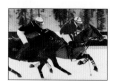

Horses seem to glide across the unusual playing field where original pass combinations are performed.

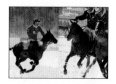

Jaime Garcia Huidobro, a Chilean player with a 7 handicap, is one of the maestros of the Cartier team. Far from the mild southern winters of his native country, he acclimates to the chills of the Swiss steppes! He drives endless swings, and is passionately devoted to the sport.

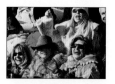

A chic audience enthusiastically goes to St. Moritz every year to watch the Cartier Polo World Cup on Snow. The event has a cult following. It is awaited and acclaimed, celebrated and adored. A winter jewel signed by Cartier and adored by a visible elite.

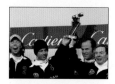

Radiant winners celebrating their victory and **success at the twentieth Cartier Polo World Cup on Snow.** The dream team consists of an Argentinean trio —Lucas Labat, Christian Labat, and Ignacio Tillous—and their Swiss captain Piero Dillier.

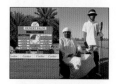

A sublime oasis in the midst of the sands of Dubai, the "Desert Palm," the luxury equestrian and residential complex built by Ali Albwardy, is home to the first polo tournament sponsored by Cartier in the Middle East.

Ali Albwardy's private museum devoted to polo holds thousands of treasures including boots, helmets, scoreboards, trophies, saddles, vintage photographs, and books that recount the epic tale of polo.

In Palenque, before the match, horses are prepared for their entrance onto the field. Their tails are braided and delicately taped so that they will not become tangled in the game of mallets. Their manes are shaved. Their glorious appearances befit these champions who are so cherished by their owners.

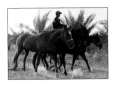

Before the sun rises, horses are prepared by passionate grooms and trainers.

Cartier oversees every detail of the **Cartier International Polo Challenge**, excelling in the art and manners of hosting.

Ali Albwardy's stables are sumptuously adorned with frescoes by an Indian artist. They are located right beside the field of honor and welcome an elite of players from every corner of the world, all anxious to visit and try out this new polo Eden.

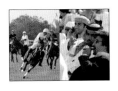

Discussion, friendship, and affinity often bring together players and spectators, united by a shared spirit.

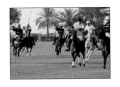

A palm tree etiquette, a carpet of green lawn, captivated spectators, competitive players. A **successful Sunday in Dubai**, where the words of the Argentinean player Julio Zaveleta (handicap 7) come to mind: "When you step foot onto a polo field, you feel free, you're alive like you are nowhere else, you vibrate. The feeling of speed, confrontation, strategy, makes you strong, invincible, and thrilled to be riding the most beautiful horses in the world."

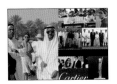

Ali Albwardy (left, with arms crossed) with guests.
Several moments during the Cartier International Polo Challenge, 2006 in particular (center, right) with Her Royal Highness Princess Haya Bint Al Hussein and the winning team of captain Urs Schwarzenbach, and (center, left) Olivier Martinez, guest star of the day, surrounded by Christine Borgoltz, Mélita Toscan du Plantier, Pilar Boxford and Jeremy Danster.

List of winners
at the Cartier International Polo
in Windsor

1984: England (A. Kent, J. Hipwood, H. Hipwood, Lord Charles Beresford) against the team Rest of the World (C. Forsyth (New Zealand), V. Gracida (Mexico), S. Novaes (Brazil), O. Richard (United States): Rest of the World won 8 to 7.

1985: England (A. Kent, J. Hipwood, H. Hipwood, P. Churchward) against Mexico (R. Gracida, C. Gracida, G. Gracida, J. Baez): Mexico won 8 to 6.

1986: England (A. Kent, J. Hipwood, H. Hipwood, S. Mackenzie) against Mexico (R. Gracida, C. Gracida, G. Gracida, A. Herrera): Mexico won 8 to 4.

1987: England (W. Lucas, A. Kent, J. Hipwood, H. Hipwood) against the United States (M. Azzaro, R. Walton, O. Rinehart, D. Smicklas): the United States won 8 to 5.

1988: England (A. Seavill, J. Hipwood, H. Hipwood, Lord C. Beresford) against the United States (M. Egloss, M. Azzaro, R. Walton, D. Smicklas): England won 8 to 7. This was the first time England beat the United States at Smith's Lawn.

1989: England (A. Hine, J. Hipwood, A. Kent, Lord C. Beresford) against an Australian-Asian team (I. Gould, C. Forsyth, S. Mackenzie, J. Gihnore): England won 10 to 8.

1990: England (W. Lucas, J. Hipwood, H. Hipwood, R. Matthews) against France (L. Tari, S. Gastambide, L. Macaire, S. Macaire): England won 6 to 5.

1991: England (W. Lucas, J. Hipwood, A. Kent, J. Lucas) against New Zealand (G. Keyte, C. Forsyth, S. Mackenzie, A. Parrott): England won 11 to 10.

1992: England (W. Lucas, C. Forsyth, A. Kent, H. Hipwood) against the United States (J. Gobin, A. Snow, O. Rinchart, R. Walton): the United States won 8 to 7, in overtime.

1993: England (W. Lucas, J. Hipwood, H. Hipwood, Lord C. Beresford) against Chile (J. Donoso, R. Vial, G. Donoso, F. Fantini): England won 8 to 3.

1994: England (J. Daniels, A. Wade, Lord C. Beresford, J. Lucas) against South Africa (M. Rattray, D. Lund, S. Armstrong, C. Hill): England won 11 to 1.

1995: England (J. Daniels, H. Brett, H. Hipwood, A. Wade) against Argentina (G. Laulhe, T. Fernandez-Llorente, B. Araya, J. Zavaleta): Argentina won 14 to 8.

1996: England (J. Daniels, H. Brett, H. Hipwood, A. Wade) against Brazil (R. Mansur, J. Junquiera, A. Diniz, S. Novaes): England won 8 to 4.

1997: The Westchester Cup. England (W. Lucas, C. Forsyth, H. Hipwood, A. Hine) against the United States (J. Arellano, M. Azzaro, G. Gracida, J. Goodman): England won 12 to 9.

1998: The Coronation Cup. England (H. Brett, J. Daniels, H. Hipwood, A. Hine) against Chile (J. Donoso, J. Huidobro, G. Donso, J. A. Itaurrate): Chile won 8 to 7.

1999: England (J. Daniels, H. Brett, W. Lucas, A. Hine) against an Australian-Asian team (J. Donoso, J. Huidobro, G. Donso, J. A. Itaurrate): Chile won 8 to 7

2000: England (J. Daniels, H. Brett, W. Lucas, A. Hine) against Argentina (J. Heanly, M. Fernandez Araujo, E. Heguy, M. Macdonough): Argentina won 10 to 9, in overtime.

2002: England (W. Lucas, H. Brett, L. Tomlinson, A. Hine) against the team Rest of the Commonwealth (F. Mannix Junior (Canada), J. Baillieu (Australia), G. Gilmore (Australia), S. Keyte (New Zealand): Rest of the Commonwealth won 11 to 10.

2003: England (W. Lucas, L. Tomlinson, H. Brett, A. Hine) against Mexico (R. Gracida, C. Gracida, M. Gracida, R. Gonzalez): England won 8 to 7.

2004: England (W. Lucas, M. Tomlinson, H. Brett, L. Tomlinson) against Chile (A. Vial, J. Donoso, G. Donoso, J. Huidobro): Chile won 10 to 8.

2005: England (H. Breu, M. Tomlinson, L. Tomlinson, M. Borwick) against Australia (D. Johnston, R. Baillieu, G. Gilmore, M. Todd): Australia won 8 to 7, in overtime.

List of winners
at the Cartier Polo World Cup
on Snow

1985: *Handicap 14*, Reto Gaudenzi, Orazio Annunziata, Gianni Berry, Yvan Guillemin.

1993: *Handicap 20-24*, Reto Gaudenzi, James Lucas, Adrian Laplacette, Mario Zindel.

1994: *Handicap 20-21*, Piero Dillier, Adriano Agosti, Tomas F. Llorente, Martin Orozco.

1995: *Handicap 19-21*, Piero Dillier, Adriano Agosti, James Lucas, Tomas F. Llorente.

1996: *Handicap 20-21*, John W. Manconi, Horacio F. Llorente, Piki Diaz Alberdi, F.M. Claessens.

1997: *Handicap 20-21*, John William Manconi, Horacio Fernandez Llorente, Alejandro Diaz Alberdi, Francis-Michael Claessens.

1998: *Handicap 20-22*, John William Manconi, Horacio Fernandez Llorente, Alejandro Diaz Alberdi, Brian Morrison.

1999: *Handicap 19-21*, Nasser Al Daheri, Luis Escobar, Hugo Barabucci, Dr. Thomas M. Rinderknecht.

2000: *Handicap 20*, John Manconi, E. Novillo Astrada, Piki Diaz Alberdi, Luginbühl.

2001: *Handicap 20*, Patrick Hermes, Milo Fernandez Araujo, Diego Braun, Mathias Hermes.

2002: *Handicap 20*, John Manconi, Satnam Dhillon, Carlos Solari, Piki Diaz Alberdi.

2003: *Handicap 20*, Piero Dillier, Lucas Labat, Ignacio Tillous, Christian Bernat.

2004: *Handicap 20*, Marek Dochnal, Jack Kidd, Martin Nero, Piki Diaz Alberdi.

2005: *Handicap 20*, Simon Holley, Nacho Gonzalez, Piki Diaz Alberdi, Chris Hyde.

2006: *Handicap 20-22*, Adriano Agosti, Jaime Huidobro, Jack Baillieu, Johnny G. Carrera.

Acknowledgments

The author wishes to thank Carla Abboud, Christophe Aertz, Arnaud Bamberger, Patrick Normand, Christine Borgoltz, Pilar Boxford, Sophie André, Florence Paul, Diane Butler, The Guards Polo Club, Horst Edenhofer, Ali Albwardy, Robert Thame and Bernard Fornas; as well as all the players and the audience shot; and Martine Assouline as well as her gold team.

Endpages: Smith's Lawn, Windsor

© 2006 Assouline Publishing
601 West 26th Street, 18th floor
New York, NY 10001, USA
Tel.: 212 989-6810 Fax: 212 647-0005
www.assouline.com

All photograph: © Aline Coquelle,
except for pages 2 and 4-5: © Archives Cartier,
page 8: © J. Guichard/Gamma,
page 9: (top left) © E. Bouvet/Gamma;
(top right) © J. Guichard/Gamma; (bottom) © Archives Cartier,
page 12: © Archives Cartier,
page 71 (botton, left): © Archives Cartier.

Translation from the French by Molly Stevens, The Art of Translation.

Photoengraving by Gravor (Suisse)
Printed by Grafiche Milani (Italy)

ISBN: 2 84323 952 4